HORIZONS

CONTEMPORARY CANADIAN LANDSCAPES

HORIZONS

CONTEMPORARY CANADIAN LANDSCAPES

SELECTED BY MARCI LIPMAN AND LOUISE LIPMAN

LESTER
&ORPEN
DENNYS
PUBLISHERS

Many people made this book possible. In particular we would like to give special thanks to the artists and their families; Mr. and Mrs. Robert Adamston, Dick Hemingway, Roger Boulet; Art Gallery of Ontario: Cathy Garside; Art Gallery of Ontario Reference Library; Mr. Yvon Brisson; Canadian Eskimo Arts Council; Mr. John P. Crabb; Dalhousie Art Gallery: Jenny Kelly; Dominion Gallery: Dr. Stern; Edmonton Art Gallery; Gallery Moos: Walter Moos; Government of Ontario Art Collection: Fern Bayer, Curator; Hollander York Gallery: Diane and Susan; Houston North Gallery: Alma Houston; Innuit Gallery: Ruby; Klonaridis Inc.: Alkis; Paul Kuhn; Martin Gerard Fine Art Inc., Edmonton; Mira Godard Gallery: Mira Godard, Philip, Nancy, Nicholas; National Gallery of Canada, Ottawa: Monique McCaig, Susan Campbell; Roberts Gallery: Jack Wildridge; Sable Castelli Gallery: Christine, Jared; Skyelar Waters.

Printed and bound by Matthews Ingham and Lake Inc.

Typesetting by Fleet Typographers

Design by Spencer/Francey Incorporated

Photo Credits: Prudence Cuming Associates, p. 27; G. Georgakakos, p. 29; Robert Keziere, p. 35; Erik Landsberg, p. 25; Eleanor Lazare, p. 13; Tom Moore, pp. 7, 9, 15, 23, 39, 43; Gabor Szilasi, p. 33.

FIRST EDITION

CANADIAN CATALOGUING
IN PUBLICATION DATA

Main entry under title:
Horizons: contemporary Canadian landscapes

ISBN 0-88619-057-6

1. Landscape painting — 20th century — Canada.
2. Landscape painting, Canadian. I. Lipman, Marci, 1948- II. Lipman, Louise, 1953

ND1352.C36H67 1985 758′.1′0971 C85-099064-5

Printed and bound in Canada for
Lester & Orpen Dennys Limited
78 Sullivan Street
Toronto, Ontario M5T 1C1

The image of the artist, brush in hand, easel propped up in a green and golden countryside, is a legacy of the turn-of-the-century Impressionists, who celebrated light and rural life, creating sketchy, luminous canvases of boating parties, fields full of sunblown poppies, waterlilies rainbowed in light.

The Canadian version — sketchpad braced against a canoe gunwale, paintbox tucked in beside some fishing tackle — is a touch more rugged, thanks to Tom Thomson and the Group of Seven, the natural heirs of the *coureurs de bois* and artist-explorers like Paul Kane and British army engineers. Here we have the artist as outdoorsman, seeking visual trophies of the wilderness, struggling to forge a national identity.

The Group of Seven's genius was geographical. Even today, an over-reproduced painting like *The Jack Pine* sets up emotional reverberations; evoking the cry of a loon, the satin ripple of a paddle stroke, it resonates with the lingering myth of Canada as a mystic northern wilderness. For many, that powerful imagery still contributes to a sense of place.

During the last few decades, artists have begun to focus on their own inner life, creating sensory landscapes. No longer content to reproduce the environment, they have been experimenting with alternate ways of seeing and feeling. Colour and form — paint contrasting or harmonizing with more paint — have become carriers of emotional content, although a stripped-down, stylized nature often remains as a kind of touchstone for abstraction.

Searching for the elemental forms and forces of nature, some artists today continue to reduce landscapes and cityscapes to carefully designed patterns — a hint of horizon, a wash of azure sky — which still manage to produce a certain sense of place. Others work in more realistic detail, often focusing on narrative moments or razor-sharp textures. Regardless of the labels used — abstraction, impressionism, high realism, folk art — all twenty of the paintings in this book give us a personalized sense of space.

Not surprisingly, the artists included in *Horizons* seem spiritually bonded to their formative environments. Christopher Pratt, a fourth-generation Newfoundlander, lives in St. Mary's Bay and is a master yachtsman — factors that inform his crystalline images. Toni Onley roams the mountain chains of British Columbia, piloting his antique plane to hazy, coastal inlets and remote islands (he recently survived a dramatic icefield crash). Kay Graham summers in Algonquin Park and makes frequent trips to the Arctic to record her luminous impressions. Angahadluq, a member of the Baker Lake co-operative, grew up in northern hunting camps; Barbara Ballachey's family owns a farm — the locale of the painting in this book — near Calgary; Ken Danby lives in a converted mill in the southern Ontario countryside. Gordon Smith, working by the ocean for most of his life, has a daily view of the changing moods and interlocking imagery of sea and sky. Even an urbanite like James Spencer chooses to paint "natural" subjects, and though the content serves as an armature for studies in colour and form, his mountains and waves are still emotional choices, based on years spent in the Rockies and in his Nova Scotia birthplace.

Landscape, however altered, however abstracted, remains one of the great recurring themes in Canadian art. *Horizons* reflects the range and richness of this elemental theme.

Meriké Weiler

Marci Lipman was born in Toronto and studied Fine Arts at York University. She is a leading art consultant and the owner of Marci Lipman Graphics in Toronto — Canada's major fine-art poster house. Louise Lipman studied at Bard College and the University of British Columbia. She is a publisher of fine-art posters and the owner of Lipman Publishing Inc.

A.J. CASSON

"Approaching Storm"
1976
65cm x 76cm
Oil on canvas
Private collection
Courtesy of the Roberts Gallery

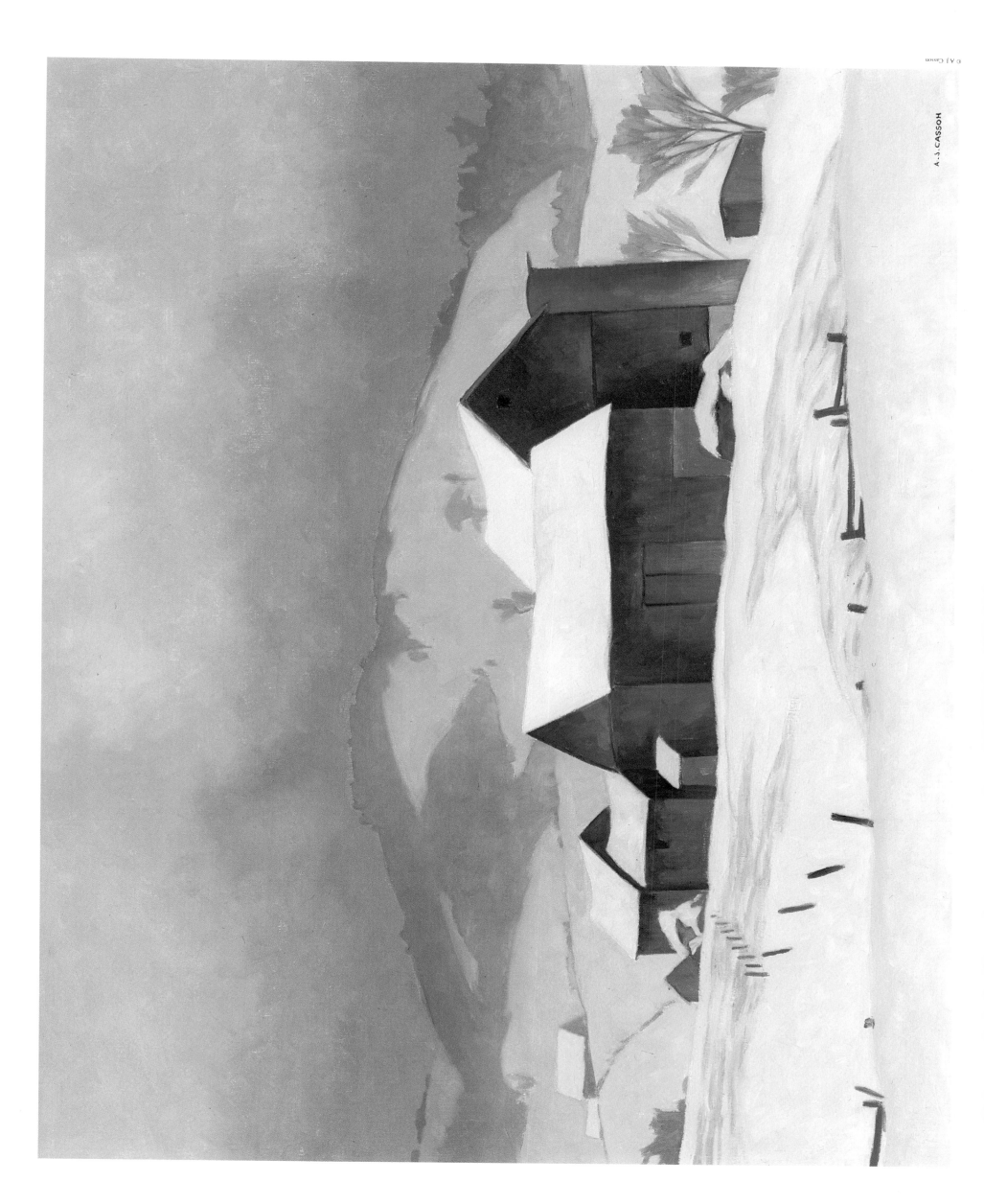

A. J. CASSON

TED HARRISON

"Old Cart"
1984
91cm x 122cm
Acrylic on canvas
Private collection
Courtesy of the Hollander York Gallery

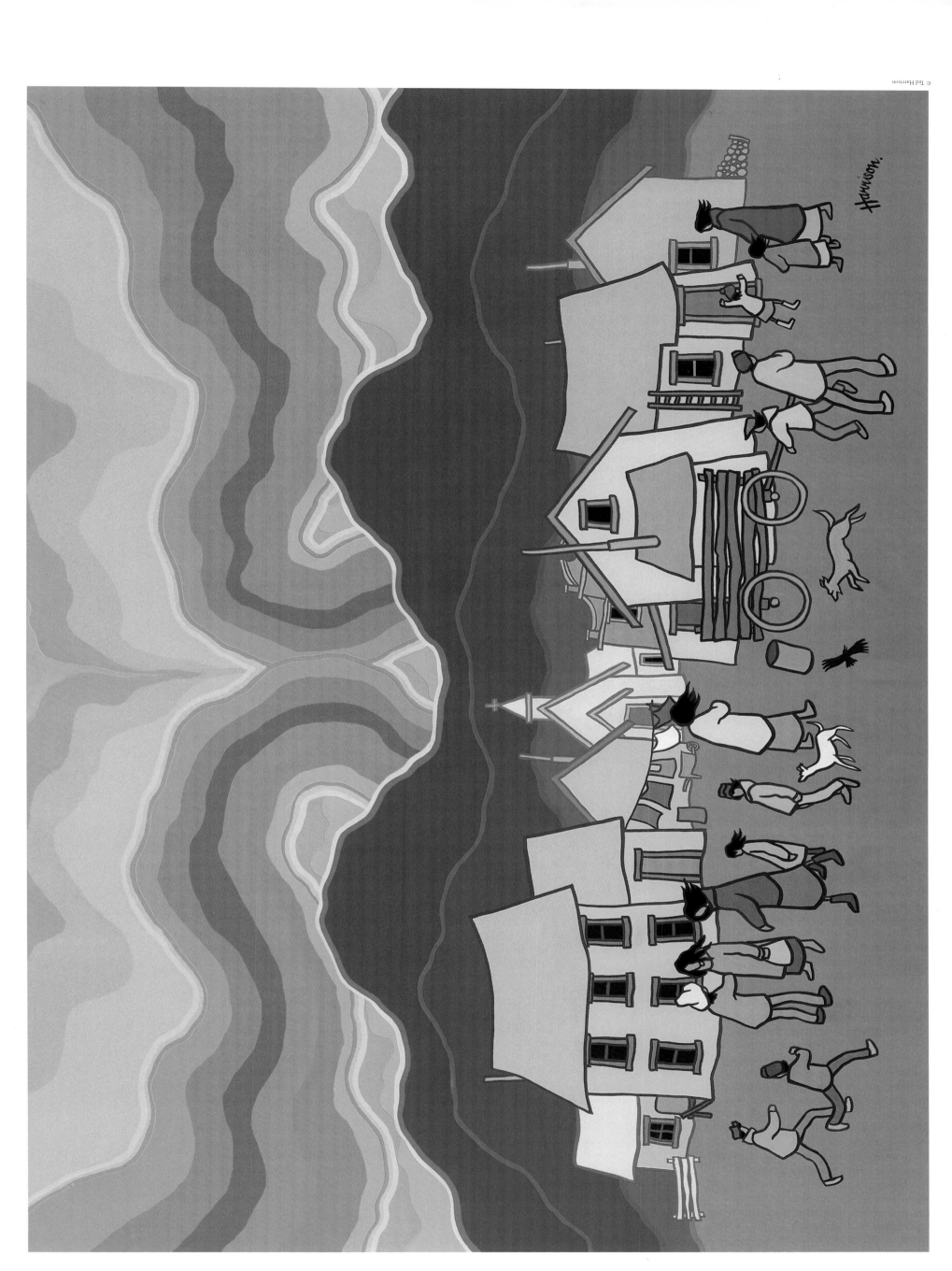

CHRISTOPHER PRATT

"Bay"
1972
81cm x 180cm
Oil on board
Private collection, Edmonton
Courtesy of the Mira Godard Gallery

12

BARBARA BALLACHEY

"West View above Sheep Creek"
1983
57cm x 76.7cm
Gouache on paper
Courtesy of Martin Gerard Fine Art Inc., Edmonton

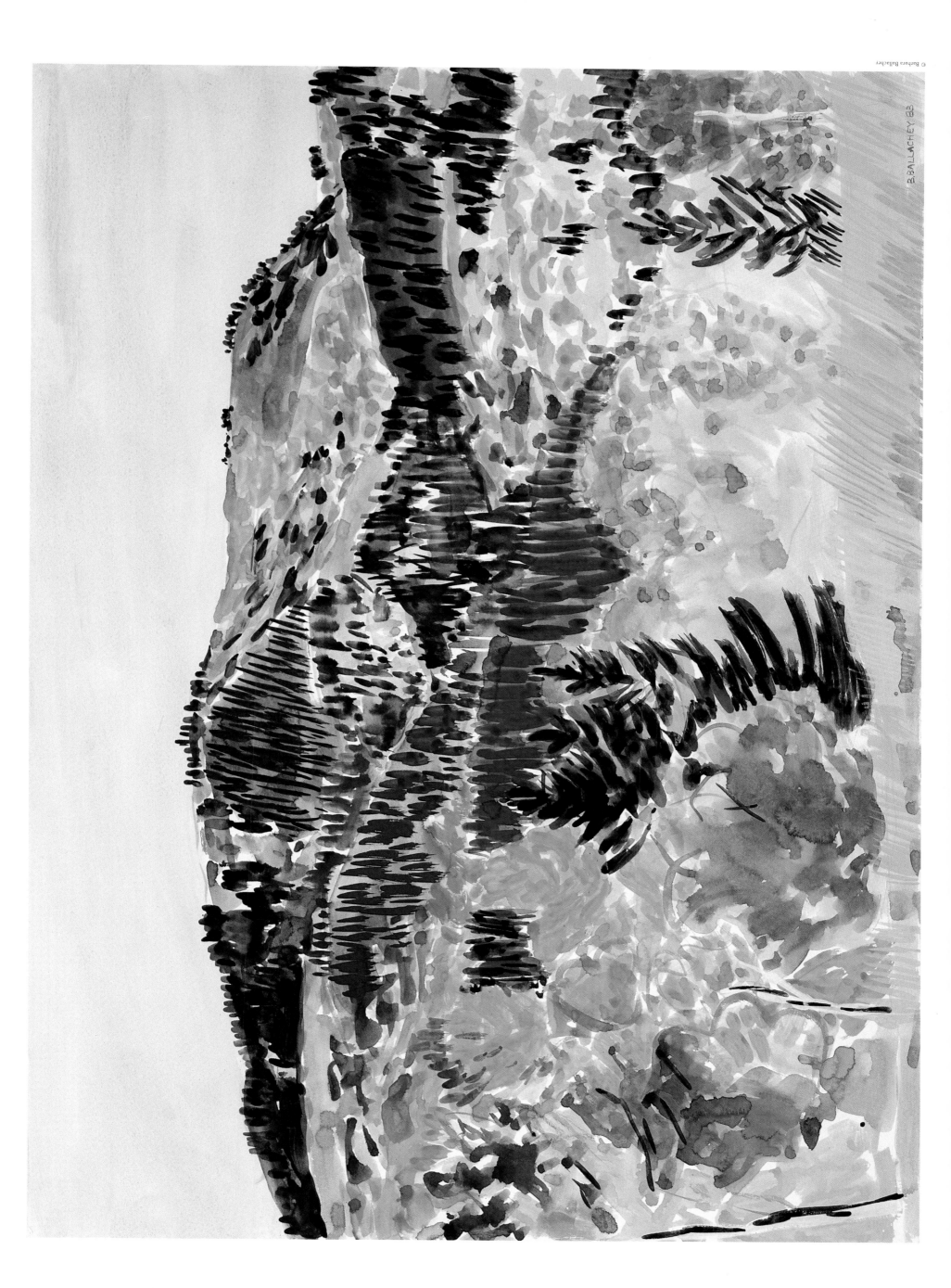

B.BALLACHEY 83

LUKE ANGAHADLUQ
MARGARET AMAROOK

"Old Caribou Hunters"
1980
53cm x 66cm
Silkscreen
The Innuit Gallery, Toronto
Reproduced by permission of
Sanavik Cooperative, Baker Lake, N.W.T.

16

E.J. HUGHES, R.C.A.

"The South End of Bamberton Beach"
1983
61cm x 91cm
Oil on canvas
Collection: the Dominion Gallery, Montreal

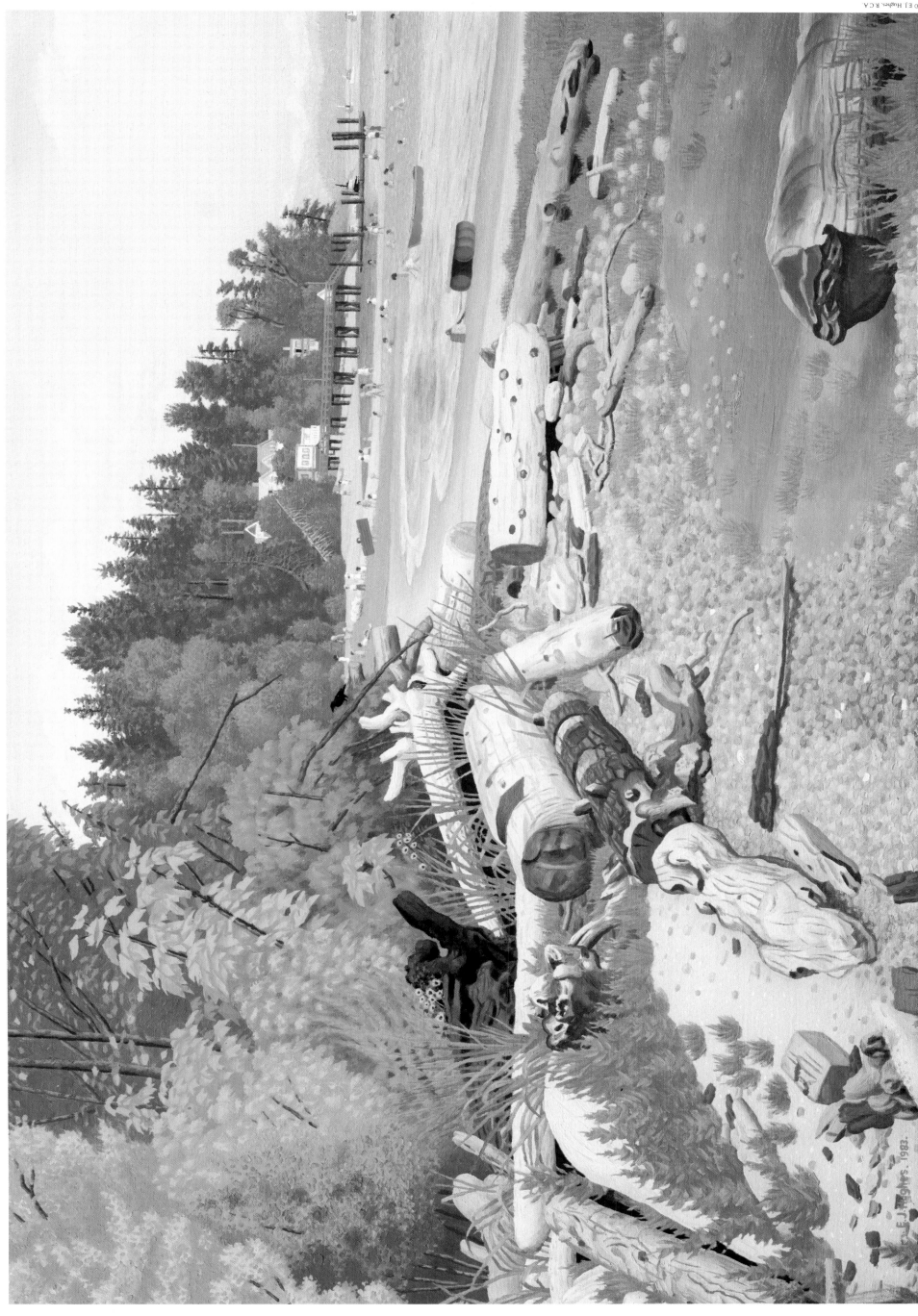

WALTER PHILLIPS

"Prairie Farm"
1937
25.7cm x 36.5cm
Watercolour on paper
Collection: John P. Crabb, Winnipeg
Courtesy of John P. Crabb

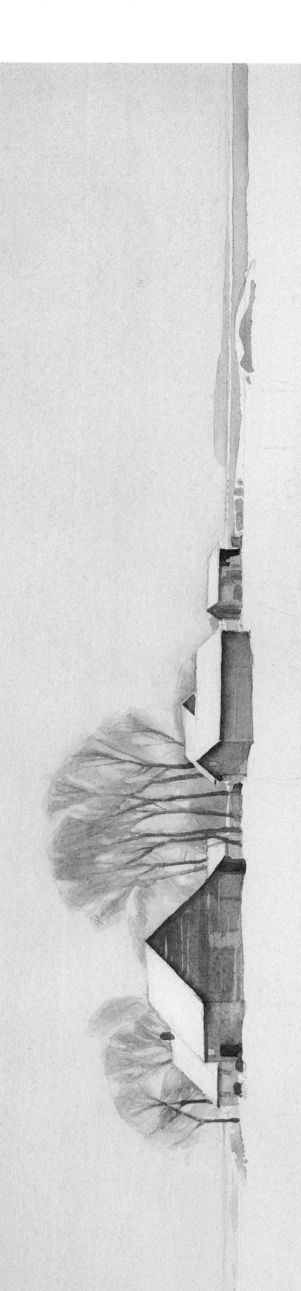

W J PHILLIPS

JAMES SPENCER

"The Wave"
1982
152cm x 213cm
Acrylic on canvas
Collection: Bell-Northern Research

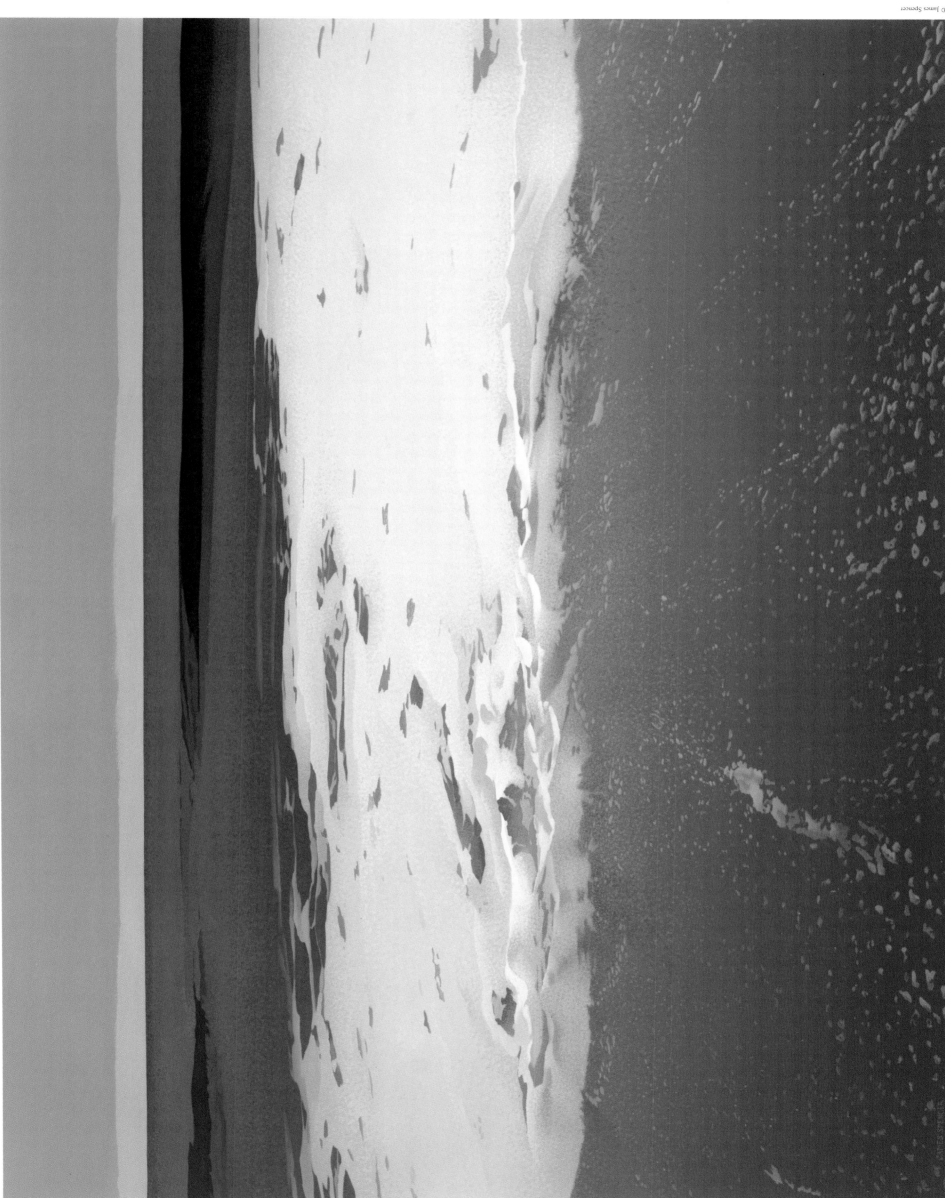

GEORGE AGNEW REID

"Evening, Lake Temagami"
1941
46cm x 58cm
Oil on canvas
Courtesy of the Government of Ontario Art Collection

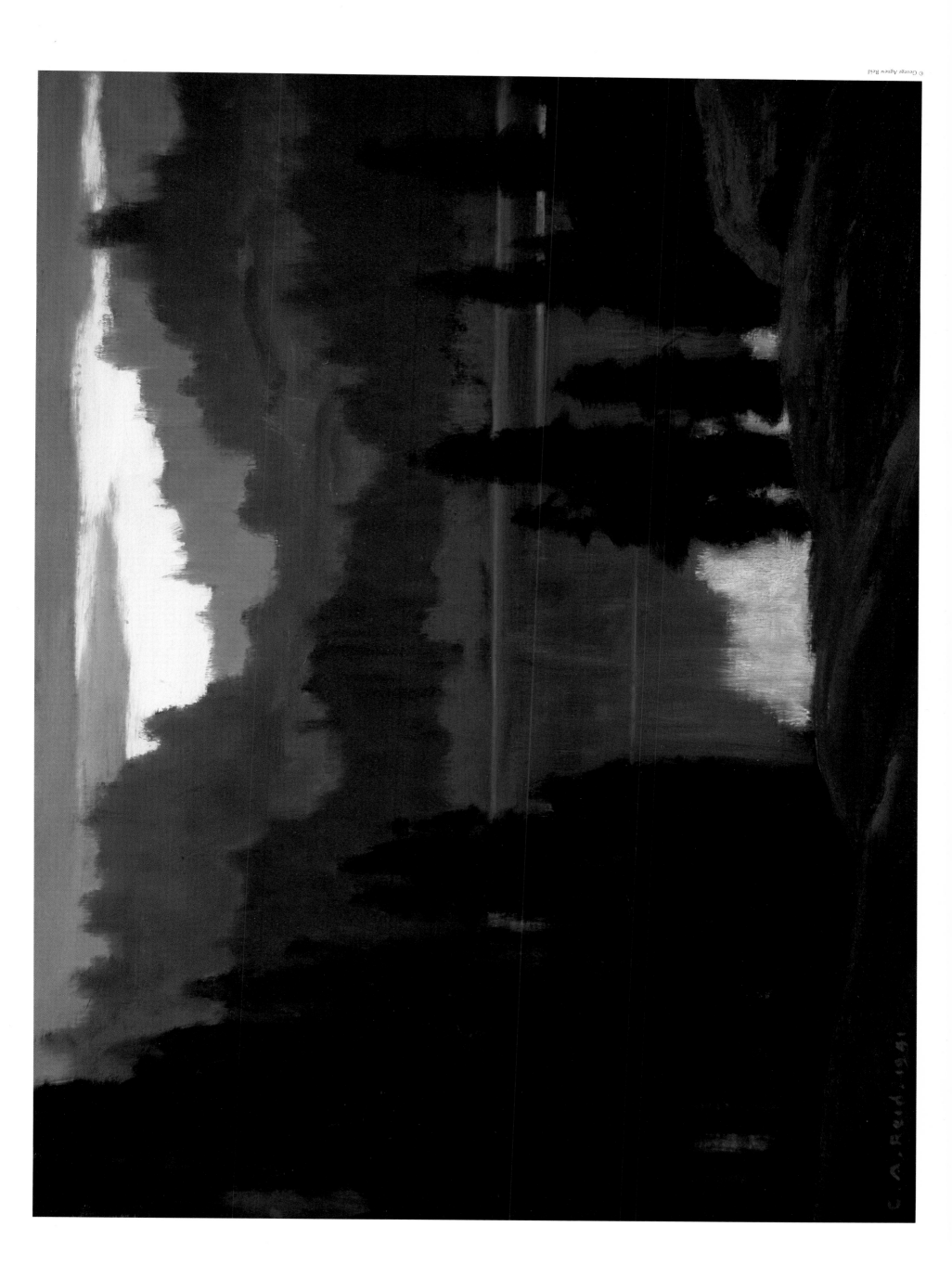

G. A. Reid. 1941

TAKAO TANABE

"Shoderee Ranch"
1984
127cm x 305cm
Acrylic on canvas
Courtesy of the Bernice Steinbaum Gallery,
New York City

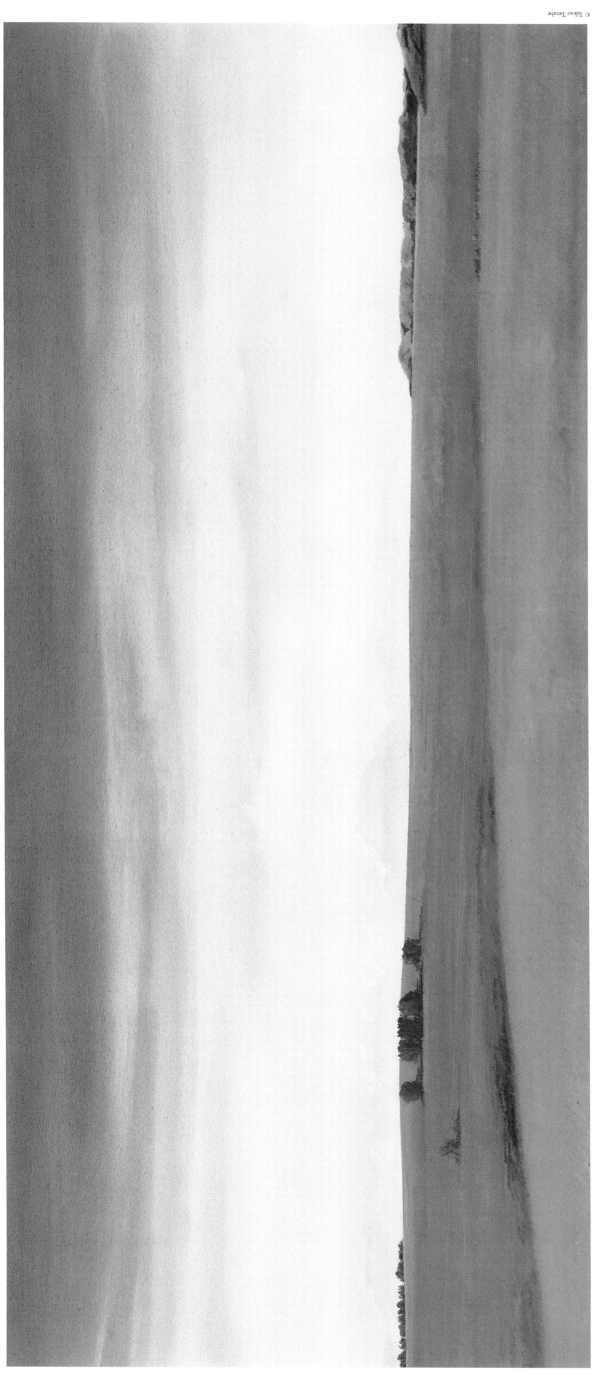

ALEX COLVILLE

"Horse and Girl"
1984
45cm x 60cm
Acrylic

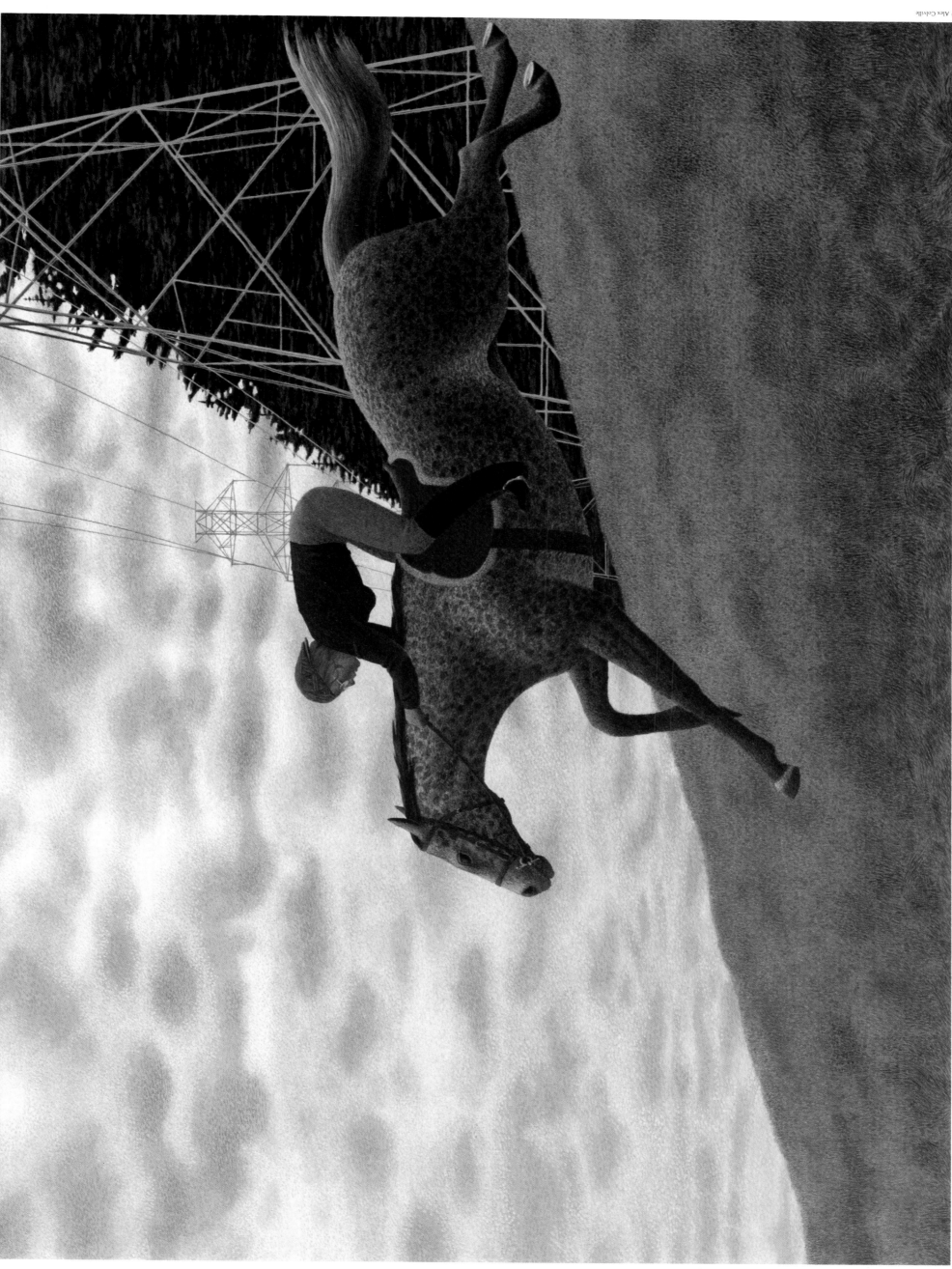

JOE NORRIS

"Snug Harbour"
1985
72cm x 87cm including frame
Hobby paint on canvas, painted wood frame
Courtesy of the Houston North Gallery

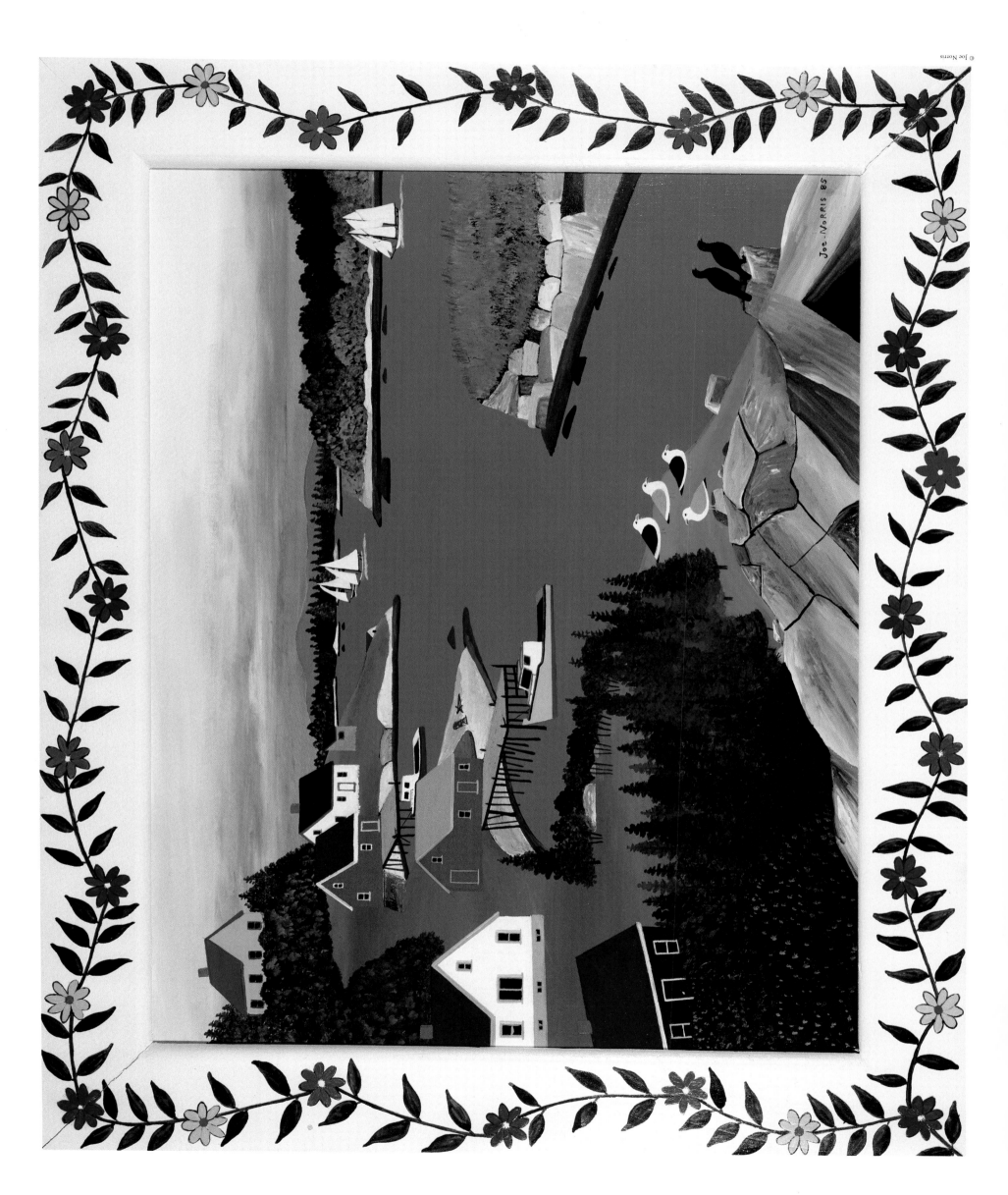

TONI ONLEY

"Silver River, B.C."
1985
28cm x 38cm
Watercolour on paper
Courtesy of the artist

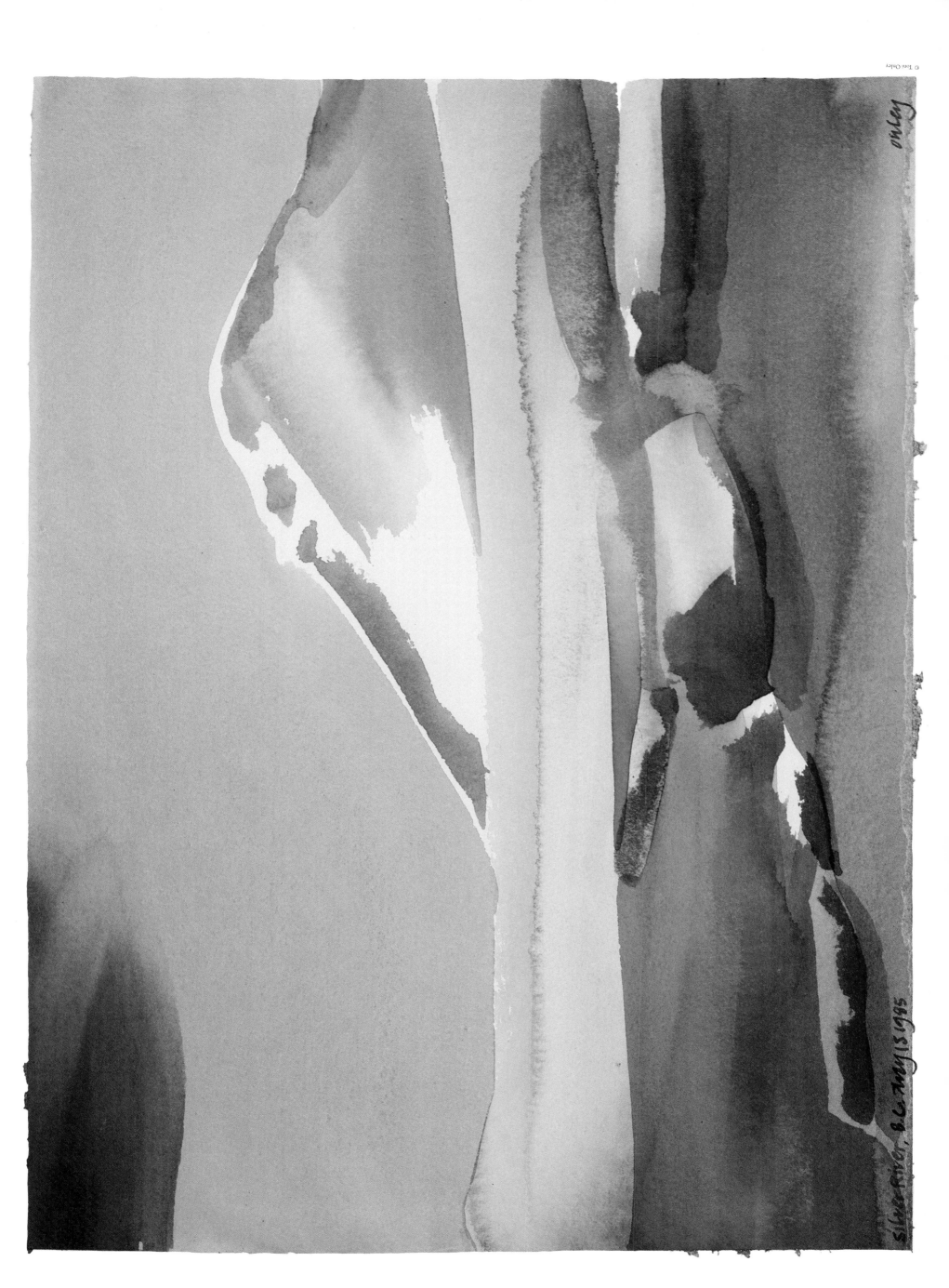

Onley

Silver River, B.C. May 15 1995

JEAN-PAUL LEMIEUX

The Night Visitor/Le visiteur du soir
1956
80cm x 110.5cm
Oil on canvas
Courtesy of the National Gallery of Canada/
Musée des beaux-arts du Canada, Ottawa

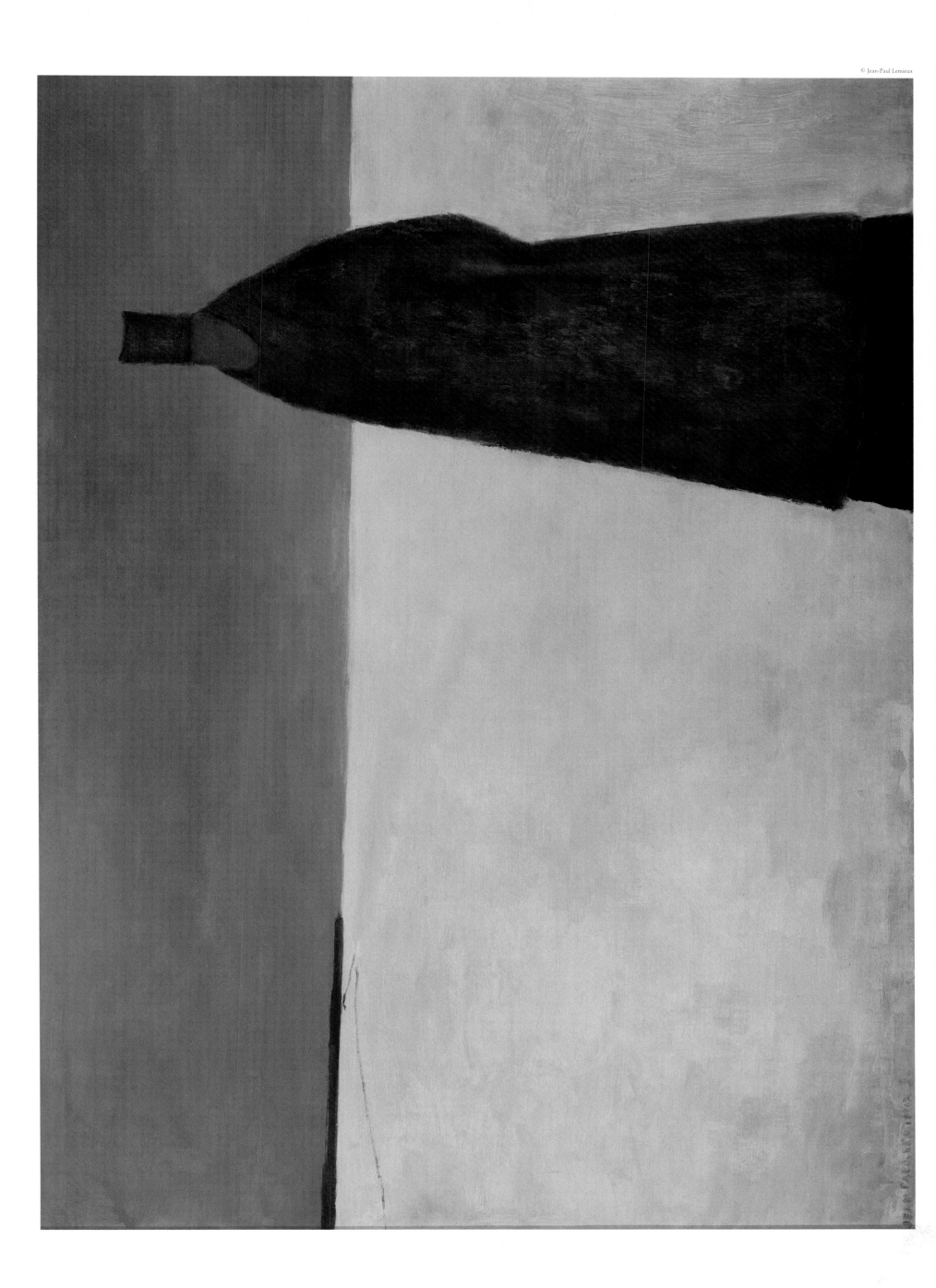

RICHARD DAVIS

"Centre City"
1978 - 1982
117cm x 137cm
Acrylic on board
Courtesy of the artist

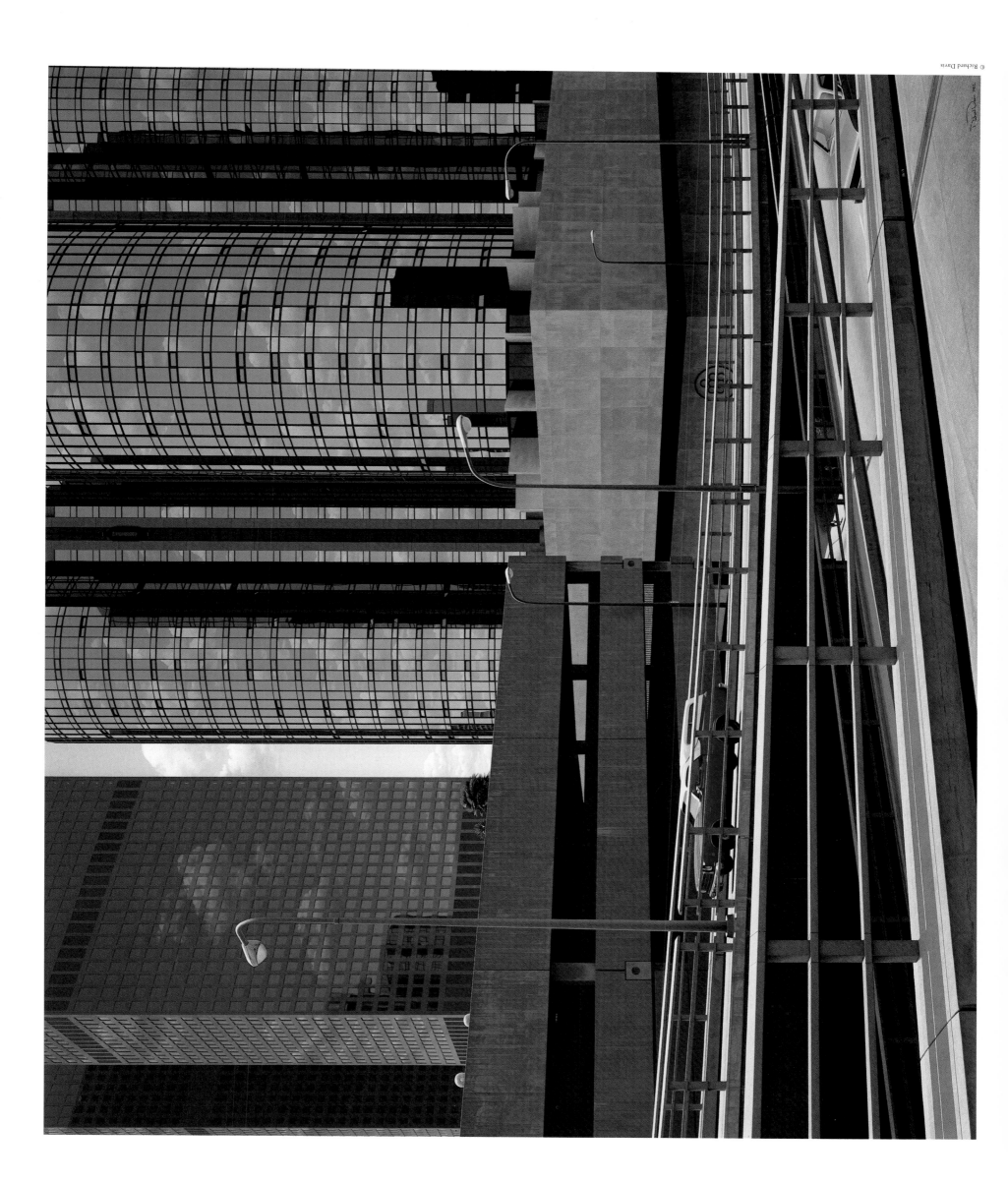

GORDON SMITH

"T. S. II"
1983/84
140cm x 165cm
Acrylic on canvas
Courtesy of the Mira Godard Gallery

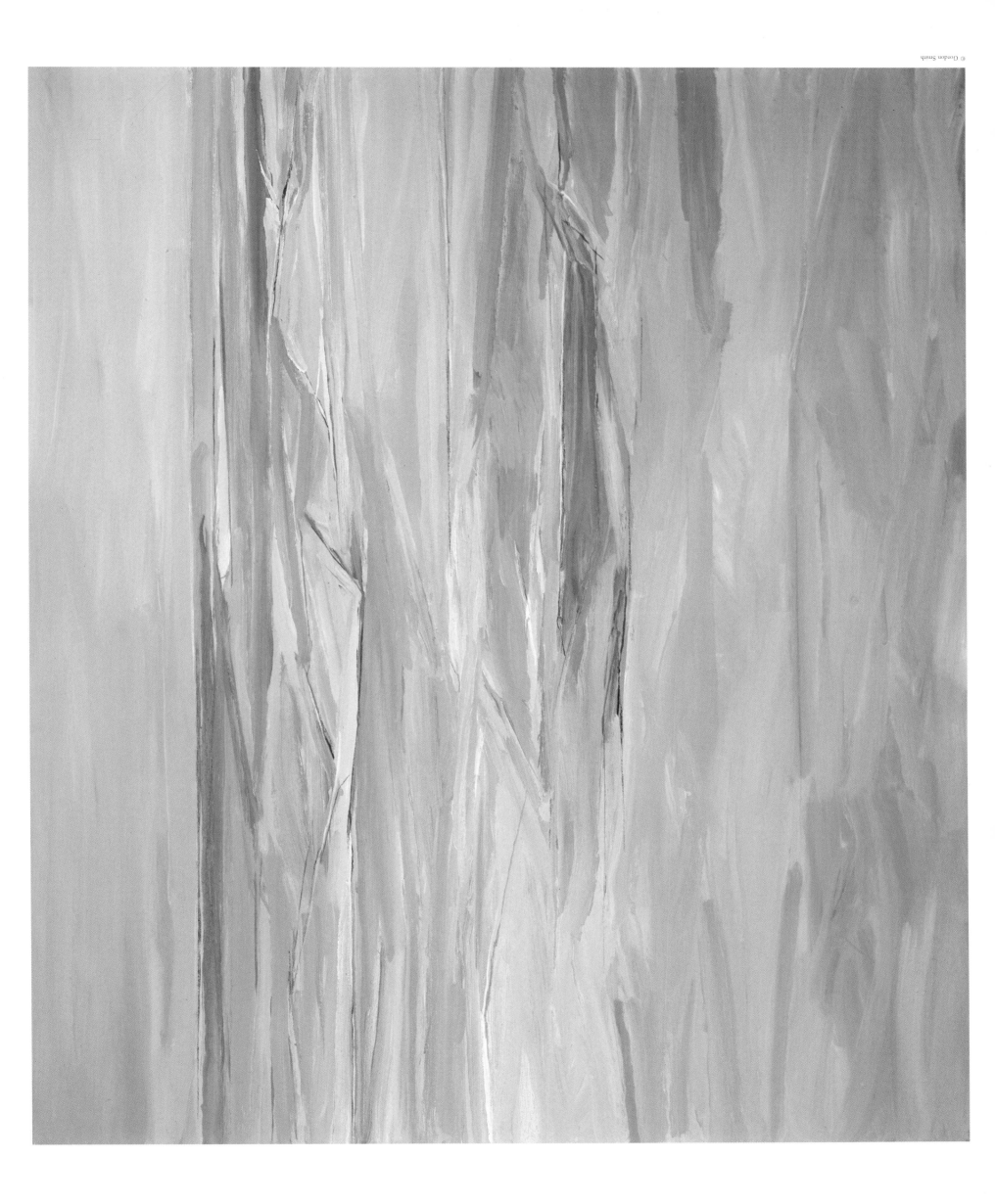

KEN DANBY

"The Swimmers"
1983
40.64cm diameter
Egg tempera
Collection: Samaco Trading Limited, Toronto
Courtesy of Gallery Moos, Toronto

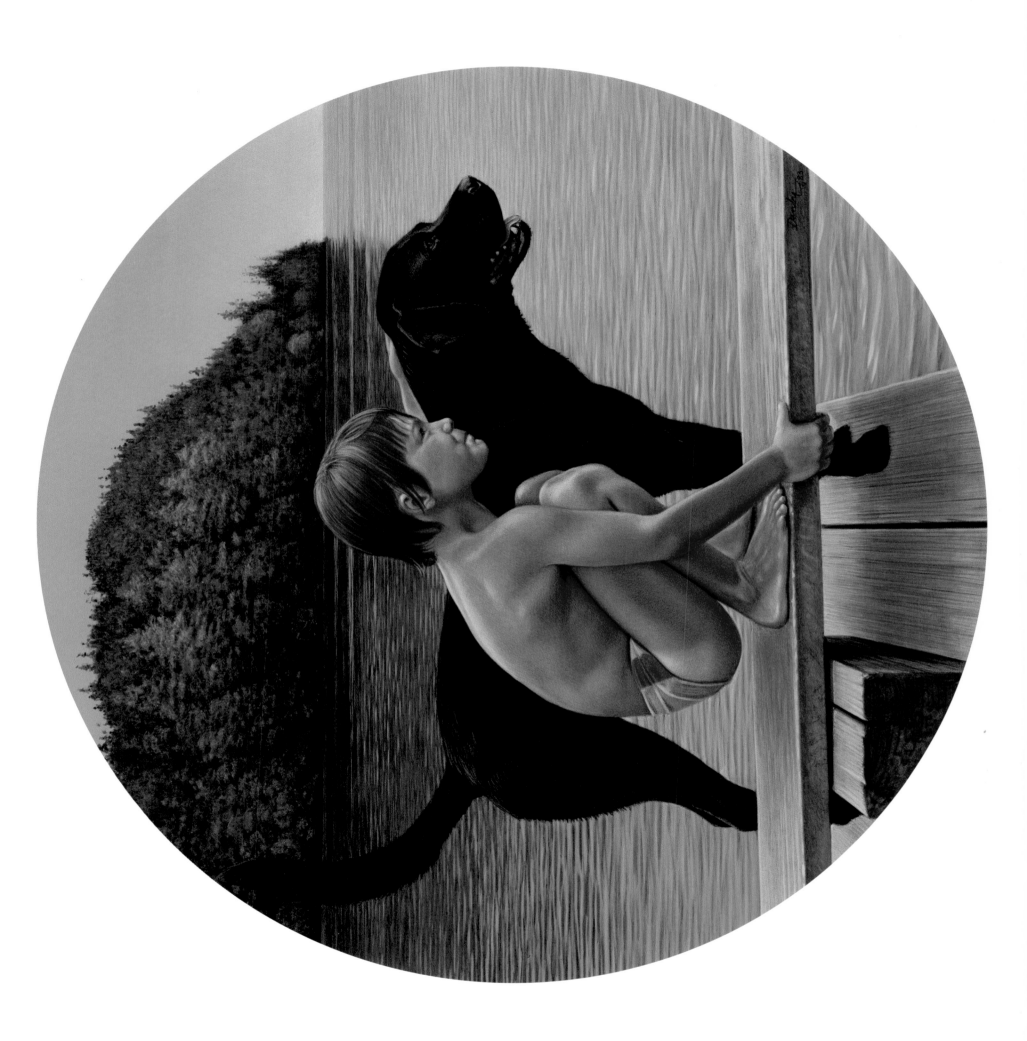

TIM ZUCK

"Bird and Memorial"
1980
76.2cm x 76.2cm
Oil on canvas
Private collection, Toronto
Courtesy of the Sable-Castelli Gallery Limited

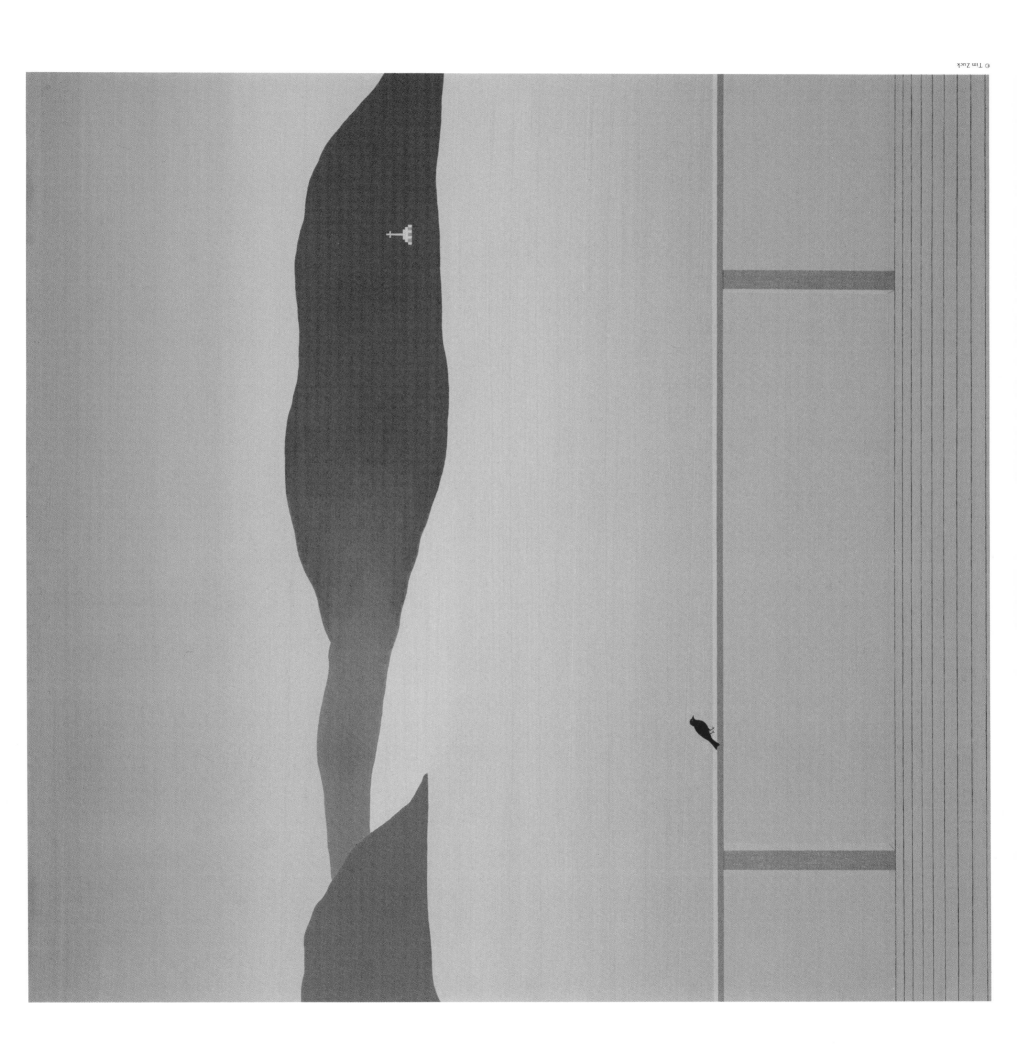

K.M. GRAHAM

"Conifers vs Hardwood"
1984
127cm x 152cm
Acrylic on canvas
Courtesy of Klonaridis Inc.

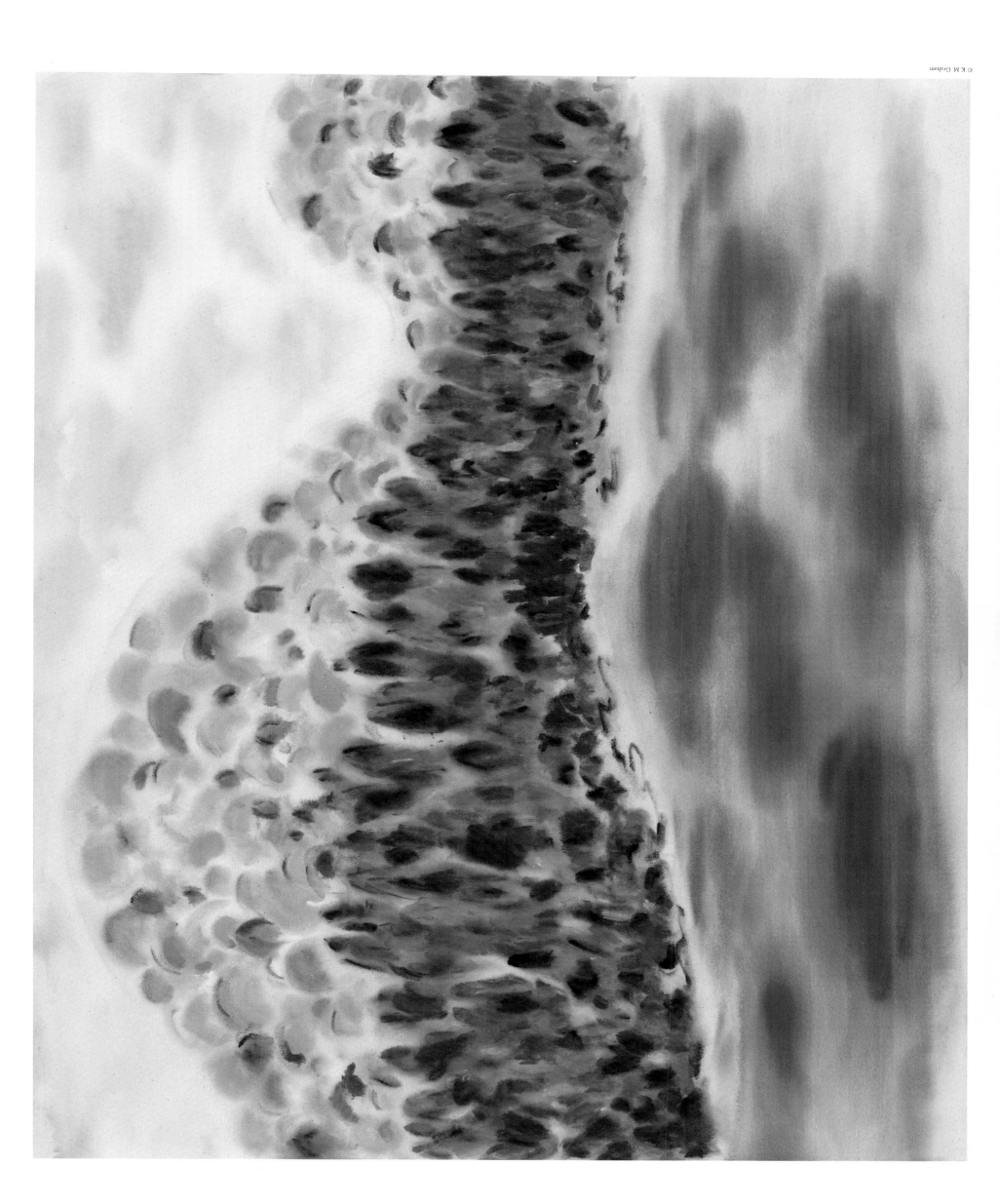

MEDRIE MACPHEE

"Station for 'Richa'"
1983
168cm x 229cm
Oil on canvas
Private collection, Montreal
Courtesy of the Mira Godard Gallery

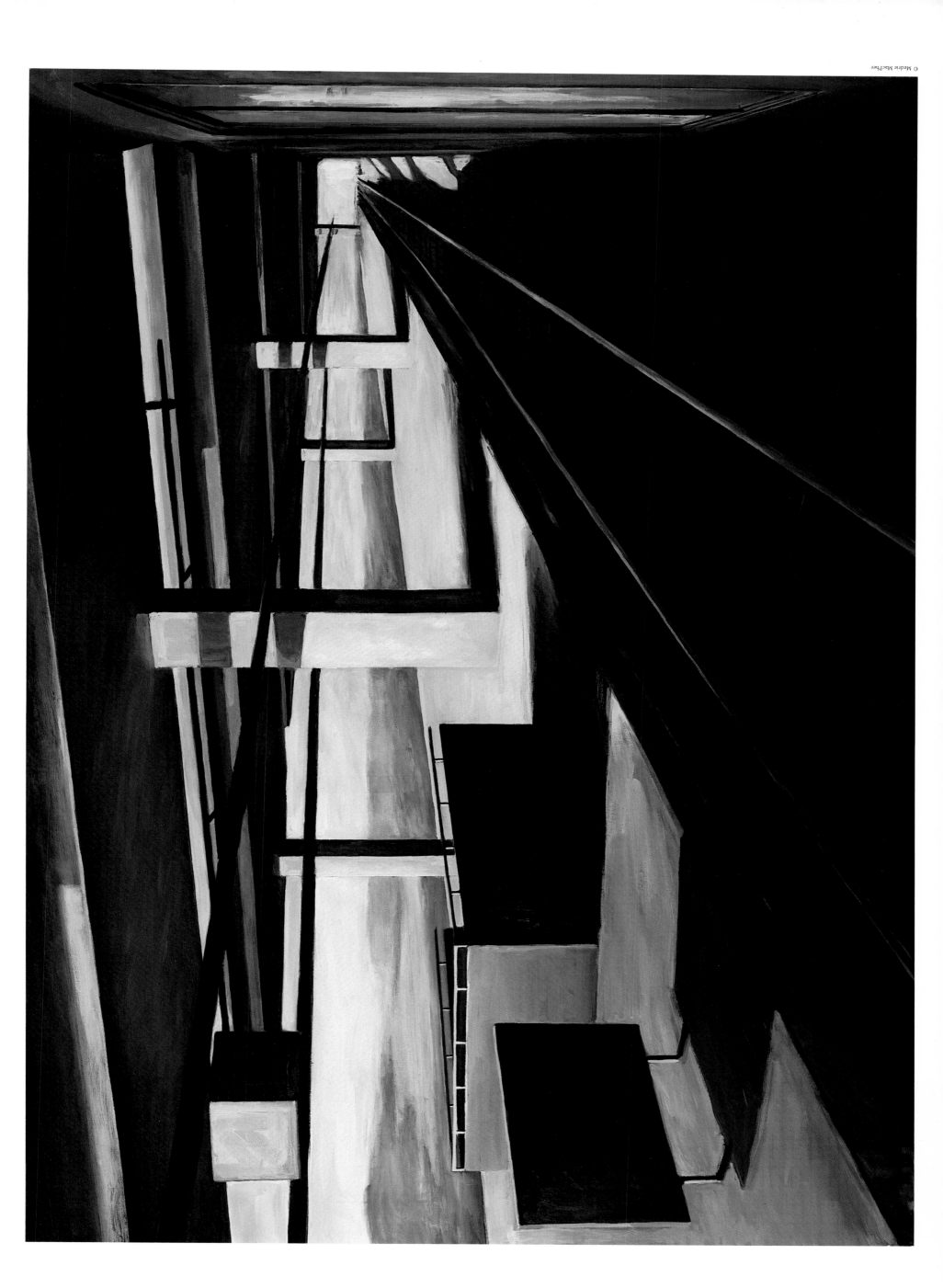

ALFRED JOSEPH CASSON was born in Toronto in 1898, and educated in Toronto and Hamilton. After an apprenticeship in lithography he studied art through night classes at the Ontario College of Art and elsewhere. In 1919 he became apprentice and assistant designer to painter Franklin Carmichael, and through him met members of the Group of Seven; Casson joined the Group in 1926.

Although Casson was vice-president and art director of Sampson-Matthews printing firm for almost twenty years, his own output has been considerable, and he has won many awards. He has been president of the Ontario Society of Artists and of the Royal Canadian Academy. Toronto remains his home.

TED HARRISON was born in 1926, in Durham County, England. He served with British Army Intelligence in India, Egypt, and East Africa, and later attended West Hartlepool College of Art, graduating in 1950. He moved to Canada in 1967, and the next year settled in Carcross, a small community in the Yukon Territory. Harrison's first major exhibit was in 1970 at the Robertson Gallery, Ottawa and he has subsequently shown his work in Vancouver, Calgary, and Toronto. In 1971 he began teaching in Whitehorse, Yukon, where he continues to reside.

CHRISTOPHER PRATT was born in St. John's, Newfoundland, in 1935. Although his grandfather encouraged him to paint from a very young age, he briefly studied both engineering at Memorial University, St. John's, and medicine at Mount Allison University, New Brunswick, before going to Glasgow School of Fine Arts in 1957. In 1959 he returned to Mount Allison, studying under Alex Colville, Lawren Harris, and Edward Pulford. He himself taught art at Memorial for two years before moving in 1963 to St. Mary's Bay, Newfoundland, where he lives with his wife, artist Mary Pratt.

BARBARA BALLACHEY was born in Edmonton, Alberta in 1949. She first studied at the Ecole des Beaux Arts in Montreal, then from 1971 to 1983 studied extensively in Calgary, Edmonton, and New York. During this time, and up to the present, Ballachey has exhibited her work throughout Canada and — in conjunction with the Alberta Art Foundation — in London, Paris, and Brussels. She currently lives in Calgary.

LUKE ANGAHADLUQ was born around 1894, in Chantrey Inlet, North West Territories. He has lived in camps — fishing and hunting — and his multi-directional drawings often portray aspects of camp life. He has worked at The Print Shop in Baker Lake, N.W.T., since it started in 1976.
MARGARET AMAROOK, who works with Angahadluq on his prints, was born in 1942, a hundred kilometres north of Eskimo Point, and moved to Baker Lake in 1951.

E.J. HUGHES, R.C.A., born in Vancouver in 1913, grew up in Nanaimo, on the east coast of Vancouver Island. At the age of sixteen he enrolled in the Vancouver School of Art, where he studied for six years under Jock MacDonald and F.H. Varley. After graduation Hughes worked as a commercial artist with Paul Goranson and Orville Fisher until 1939, when he enlisted with the Royal Canadian Artillery; he was appointed Official War Artist in 1942. After his discharge Hughes returned to Victoria, and in 1951 moved to nearby Shawnigan. He was discovered by Dr. Max Stern and had his first show at the Dominion Gallery in Montreal in 1954. He still lives in Shawnigan.

WALTER J. PHILLIPS was born in Barton-on-Humber, Lincolnshire, England, in 1884. In 1913 the family immigrated to Canada and settled in Winnipeg, where Phillips worked as an illustrator. He travelled extensively throughout the country, documenting the landscape, and in the early 1940s went west to Calgary, where he taught art at the Banff summer school. Due to illness Phillips finally settled in Victoria, B.C., where he died in 1963.

JAMES SPENCER was born in 1940 in Wolfville, Nova Scotia, where he attended Acadia University before going on to the Ontario College of Art. Spencer has taught art at Central Technical School, Toronto; Mohawk College, Hamilton; Dundas Valley School of Art; McMaster University, Hamilton; and the Banff School of Fine Arts. He lives in Toronto.

GEORGE AGNEW REID was born in Wingham, Ontario in 1860. As a young man he studied art in Philadelphia, Paris, and Madrid. After returning home in 1890 he devoted many years to painting the landscapes of Ontario, Quebec, and upstate New York. During the early 1900s, Reid helped found an art museum which was to become the Art Gallery of Ontario. From 1912 to 1929 he was the first president of the Ontario College of Art. In 1944 Reid donated over four hundred of his own paintings to the Ontario Department of Education; more than half were found missing when the collection was catalogued in 1977.

During his retirement Reid devoted his energies to painting mural commissions, the last of which was for the Royal Ontario Museum. He died in Toronto on August 23, 1947.

TAKAO TANABE was born in 1926 in Prince Rupert, British Columbia. He began his studies at the Winnipeg School of Fine Art, then in 1951 studied at the Brooklyn Museum of Art, New York, under Hans Hoffman. After two years in New York, Tanabe spent a year at the Banff School of Fine Arts and in 1954 received a scholarship to the Central School of Arts and Crafts in London, England. In 1959 he went to study under Isao Hirayama at the Tokyo University of Fine Art. He became an Associate Member of the Royal Canadian Academy in

1967 and from 1979 to 1983 was an Artist in Residence and head of the Drawing & Painting Department at Banff. He has exhibited his art throughout Canada, South America, and Europe. He presently lives in Parksville, B.C.

ALEX COLVILLE lives in Sackville, Nova Scotia. He was born in 1920 in Toronto, but in 1929 his family moved to Amherst, Nova Scotia, where he joined painting classes run by Mrs. Sarah S. Hart. There he met Stanley Royle, who recommended that he study at Mount Allison University. In 1942 Colville graduated from Mount Allison with a B.F.A. From 1944 to 1946 he was an Official War Artist in the Mediterranean and Northern Europe; he returned to Mount Allison in 1946 to teach painting, drawing, and art history. In 1963 he had a sell-out show at the Banfer Gallery in New York and decided to leave teaching; he has devoted himself to painting since then.

JOSEPH NORRIS was born in 1924, in Halifax, Nova Scotia, but since the age of seven has lived in Lower Prospect. His education was hindered by chronic pleurisy, but he learned to pass the time by painting. Norris worked at construction and fishing until the age of forty-nine, when he suffered a major heart attack. It was during his convalescence that he began painting seriously, and finally gained recognition.

TONI ONLEY was born in 1928, on the Isle of Man, England. In 1943 he came to Canada, where he attended the Doon School of Fine Art in Ontario; later he studied at the Allende Instituto in Mexico. Onley is a member of the Canadian Society of Painters in Watercolour and the British Columbia Society of Artists, as well as the Royal Canadian Academy.

JEAN-PAUL LEMIEUX was born in Quebec City in 1904. He studied with the Brothers of the Christian Schools in California, returning to Montreal in 1917 to Loyola College. He subsequently attended the Ecole des beaux-arts, Quebec, until 1934 — including a year of study in Paris in 1929. From 1937 to 1965 he taught at the Ecole des beaux-arts. Today he lives and paints in Quebec City and Isle-aux-Coudres, Quebec.

RICHARD DAVIS was born in Middletown, New York, in 1947, and entered the Pennsylvania Academy of Fine Arts in Philadelphia in 1965. In 1968 he came to Canada, and he became increasingly involved in fine art here until, in 1972, he committed himself to work as a full-time painter and print-maker. Davis now lives in Vancouver.

GORDON SMITH, born in 1919 in Hove, England, came to Canada in 1934 and settled in Winnipeg. He studied at the Winnipeg School of Art under LeMoine FitzGerald. After serving in the Canadian army he moved to Vancouver, teaching graphics and commercial design at the Vancouver School and eventually joining the Faculty of Education at the University of British Columbia. In the interim he also studied at Harvard University and under Elmer Bischoff at the California School of Fine Arts.

KEN DANBY was born in Sault Ste. Marie, Ontario, in 1940. He studied under Jock MacDonald at the Ontario College of Art between 1957 and 1960 and then worked commercially in Toronto. In 1962, after attending an Andrew Wyeth show, Danby decided to move away from abstract painting and back to realism. In 1964 he began painting full time and showing with Gallery Moos in Toronto. In 1966 he moved to Rockwood, near Guelph, Ontario. Danby gained international recognition for his 1972 painting "At the Crease", and went on to paint the greatest sporting events in the world, including the 1983 America's Cup and the 1984 Winter Olympics.

TIM ZUCK was born in Erie, Pennsylvania, in 1947. After travel and study abroad, he came to Canada and received his B.A. in Fine Arts at the Nova Scotia College of Art and Design in 1971. A year later he completed his M.A. at the California Institute of Arts.

Zuck's paintings have been exhibited throughout Canada, beginning with his first group show in Toronto at the A-Space Gallery, 1971. In 1976 and 1977, the Art Gallery of Nova Scotia set up a travelling exhibit of his work which toured extensively across the country. Zuck is currently working at the Banff School of Fine Arts in Alberta.

KATHLEEN MARGARET GRAHAM (née Howitt) was born in 1913 in Hamilton, Ontario. She received a B.A. from Trinity College, University of Toronto, in 1936. Graham acted on a long-standing ambition to take up painting full-time following her husband's death in 1962. While she attended figure drawing classes and joined a local sketching group, she is essentially a self-taught painter, influenced by her friend and mentor, Jack Bush.

In 1971 Graham made the first of five trips to the Eastern Arctic, where she produced several series of lithographs at the West Baffin Co-operative studio. She returned to Cape Dorset often between 1973 and 1976 and is responsible for the introduction of acrylic paints among Inuit artists there. She now lives in Toronto, and spends her summers in Algonquin Park.

MEDRIE MACPHEE was born in Edmonton, Alberta in 1953. After receiving a B.F.A. scholarship, MacPhee attended the Vancouver School of Art in 1974, then continued her studies at Cooper Union School of Art in New York, receiving her degree at the Nova Scotia College of Art and Design in Halifax in 1976. Since this time she has exhibited extensively in Toronto, Halifax, Calgary, and Edmonton, as well as in New York, where she now lives.